Bears
Behaving
Badly

PHOTOGRAPHS BY
PAUL CYR

JOHN McDONALD

Down East Books

Published by Down East Books
An imprint of Globe Pequot
Trade division of The Rowman & Littlefield Publishing Group, Inc.
4501 Forbes Boulevard, Suite 200, Lanham, Maryland 20706
www.rowman.com

Unit A, Whitacre Mews, 26-34 Stannary Street,
London SE11 4AB, United Kingdom

Distributed by NATIONAL BOOK NETWORK

Design by Lynda Chilton, Chilton Creative

British Library Cataloguing in Publication Information Available

Library of Congress Cataloging-in-Publication Data Available

ISBN 978-1-60893-603-8 (cloth : alk. paper)
ISBN 978-1-60893-604-5 (electronic)

♾™ The paper used in this publication meets the minimum
requirements of American National Standard for Information
Sciences—Permanence of Paper for Printed Library Materials,
ANSI/NISO Z39.48-1992.

Printed in the United States of America

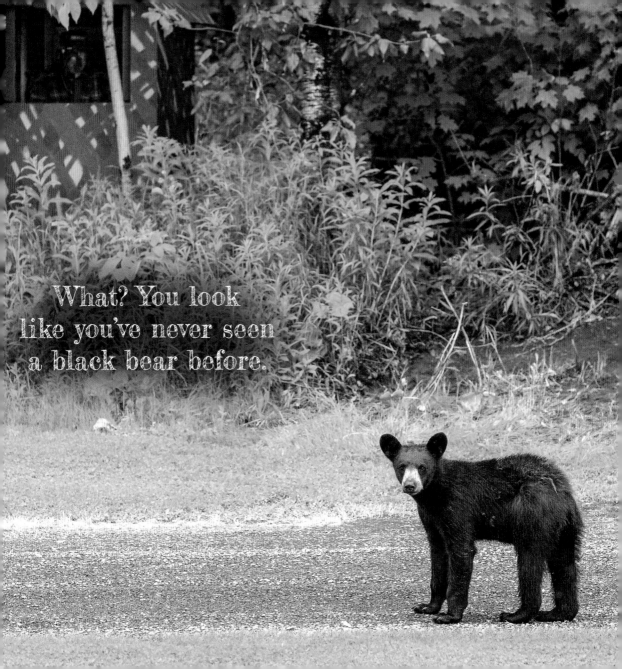

Outta my way
Annie Leibovitz, this
is my cover shoot.

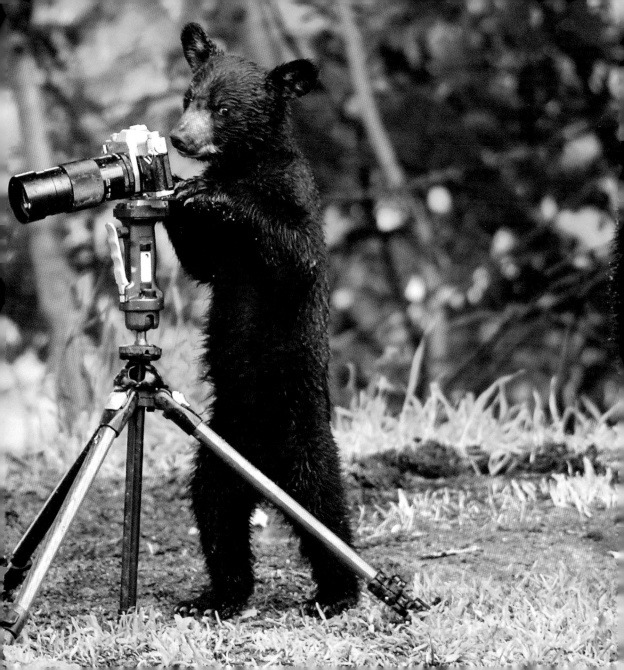

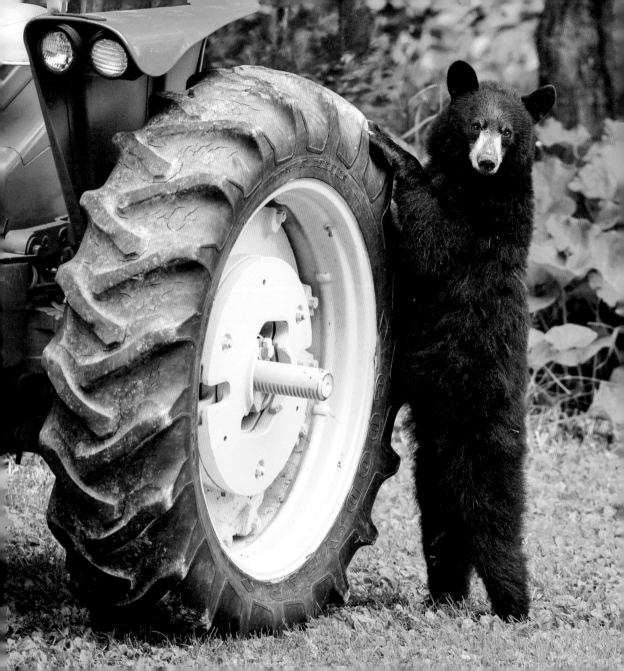

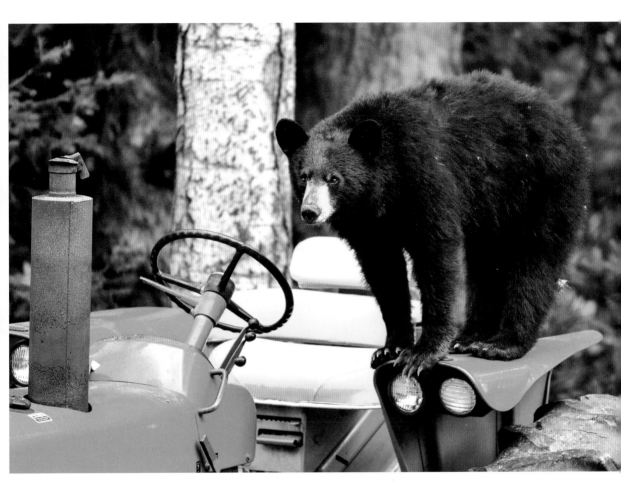

Once I get this rig going, who's going
to stop me? Nobody, that's who!

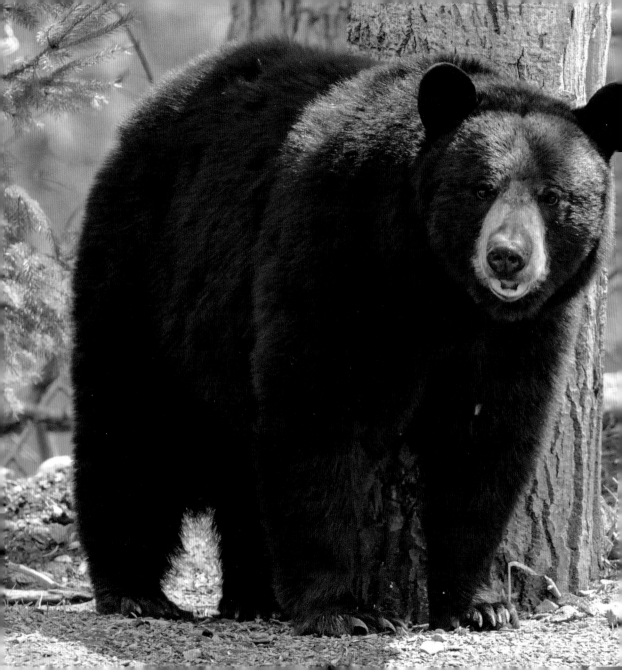

How'd I get to be 400 pounds just eating blueberries?

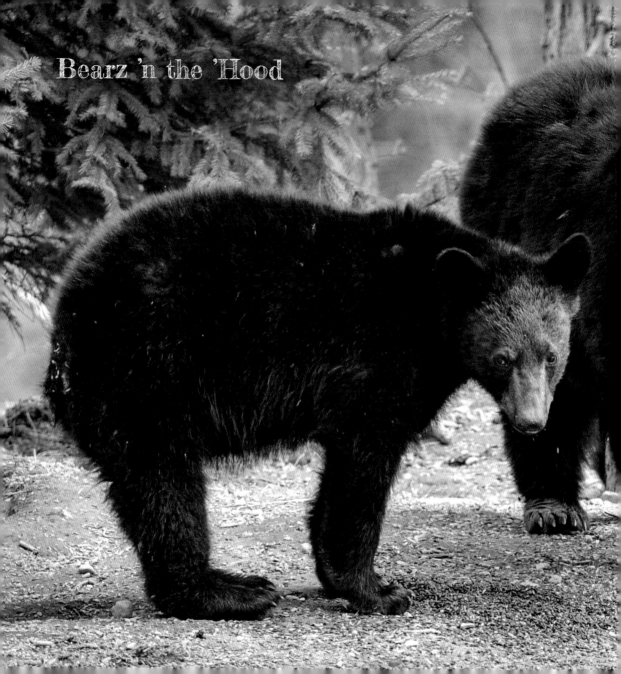

Bearz 'n the 'Hood

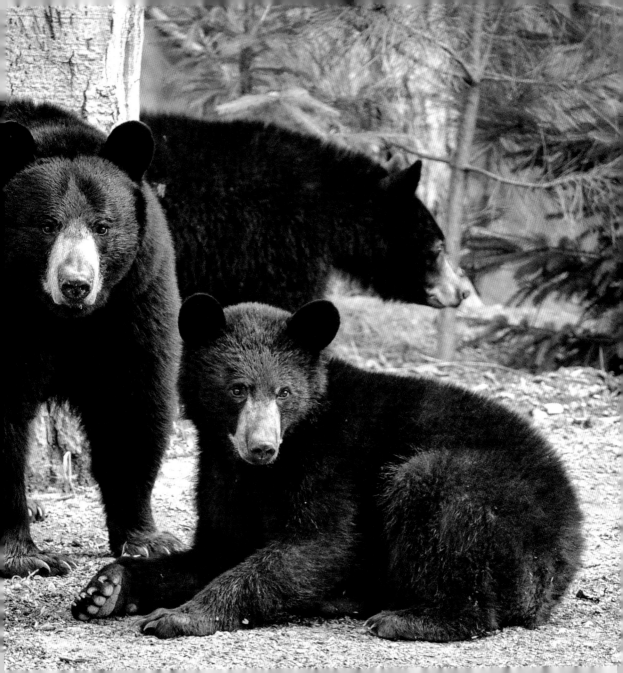

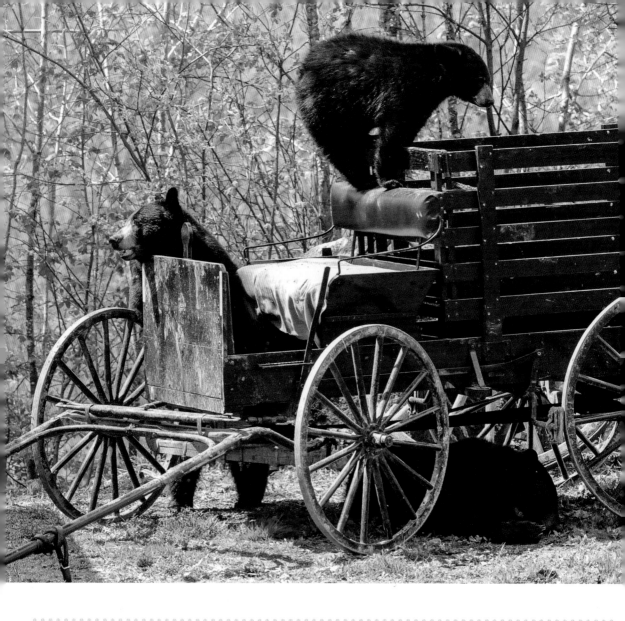

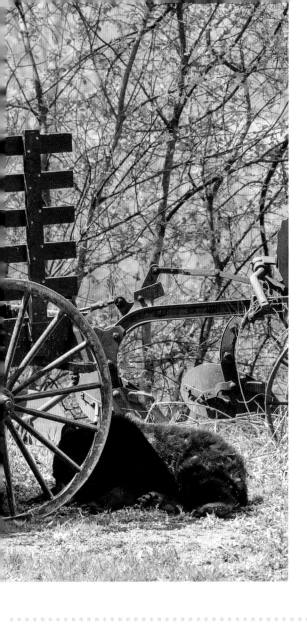

This wagon makes me think of the Wild West. Too bad nothing wild ever happens around here.

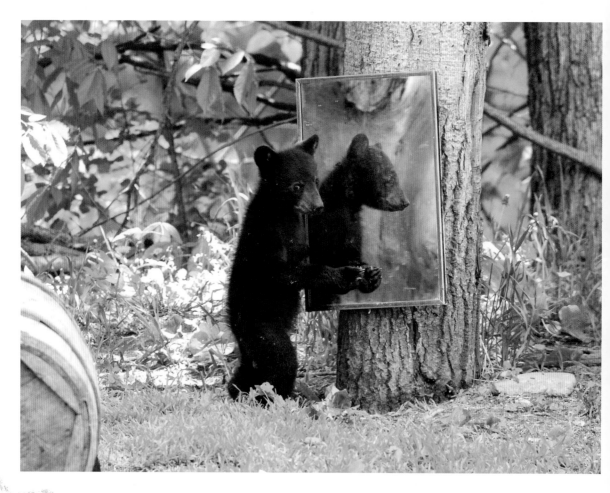

Like Momma always says, there's no
off switch for cute.

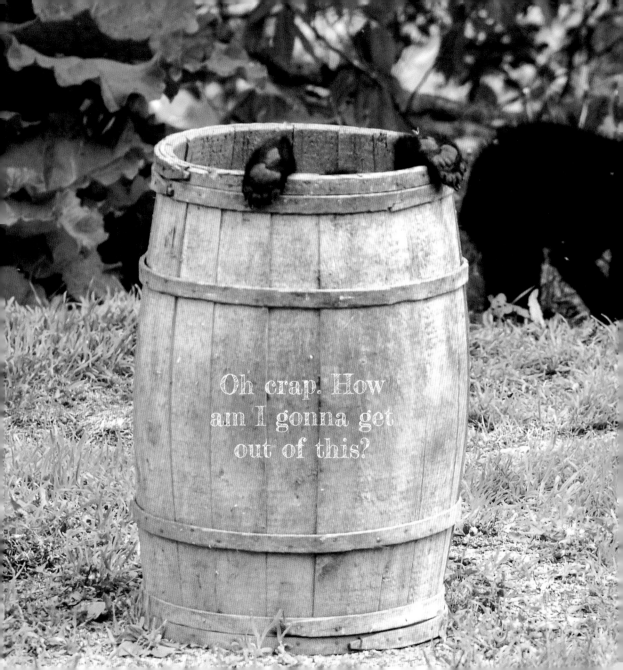

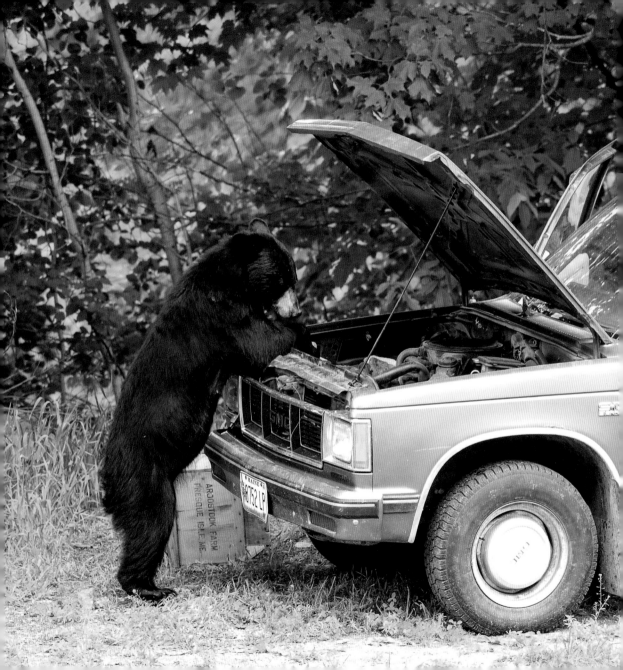

This would be a lot
easier with opposable
thumbs.

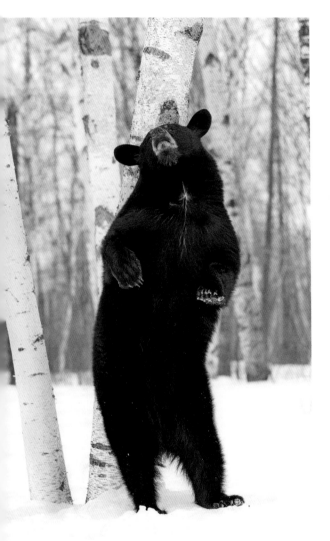
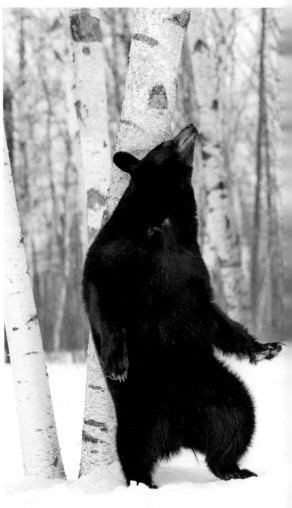

Ooh, that feels so good. My skin gets so dry in the winter.

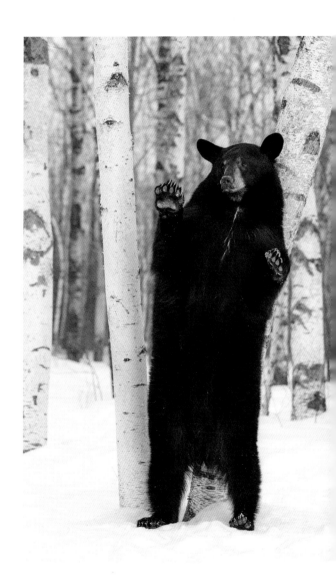

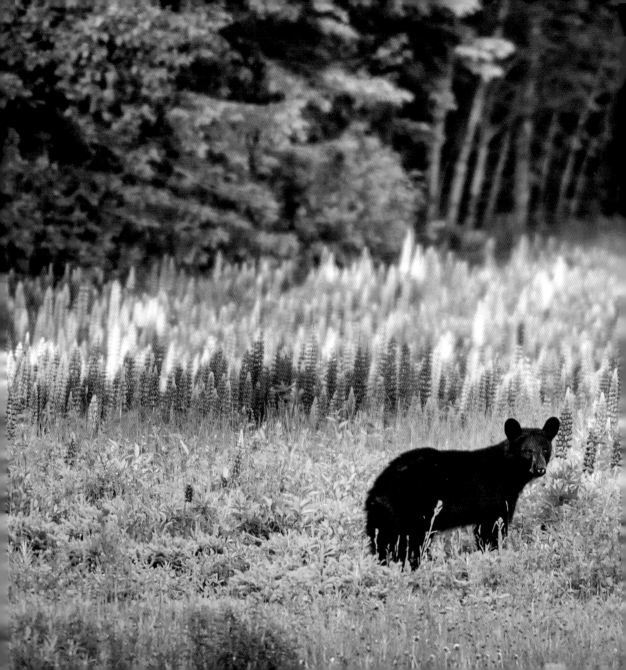

Sure, it's pretty,
but you can't eat
the scenery.

Bears aren't supposed
to worry, but I'm a
little worried.

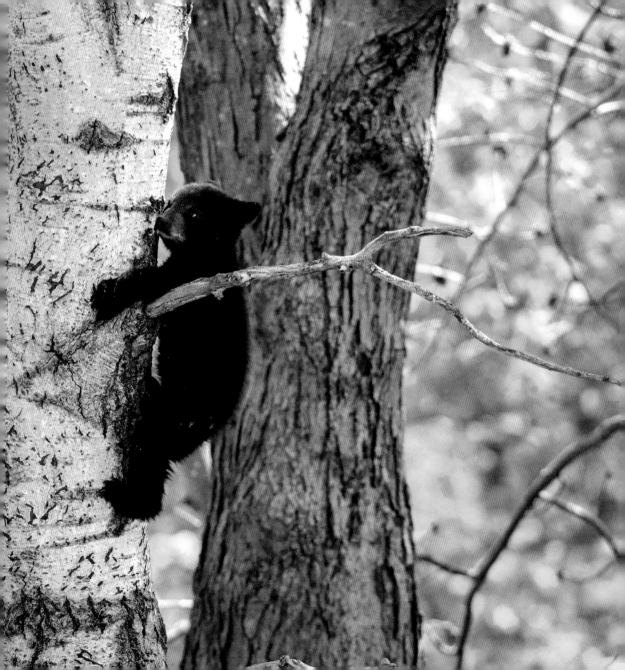

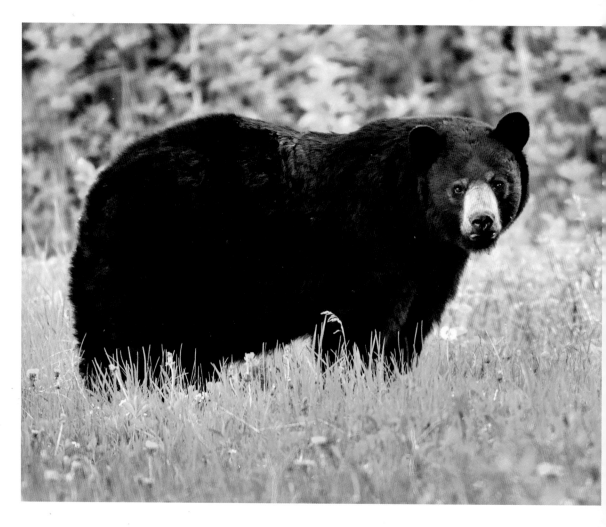

Why don't you come over here and say that.

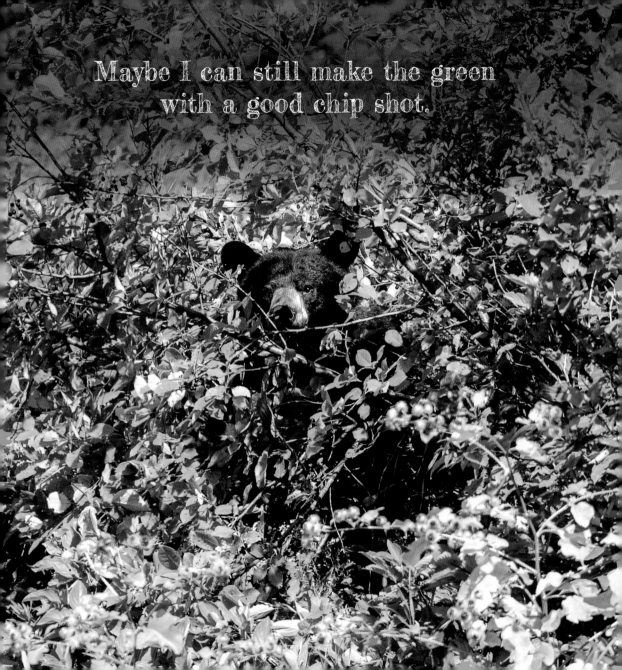

Maybe I can still make the green
with a good chip shot.

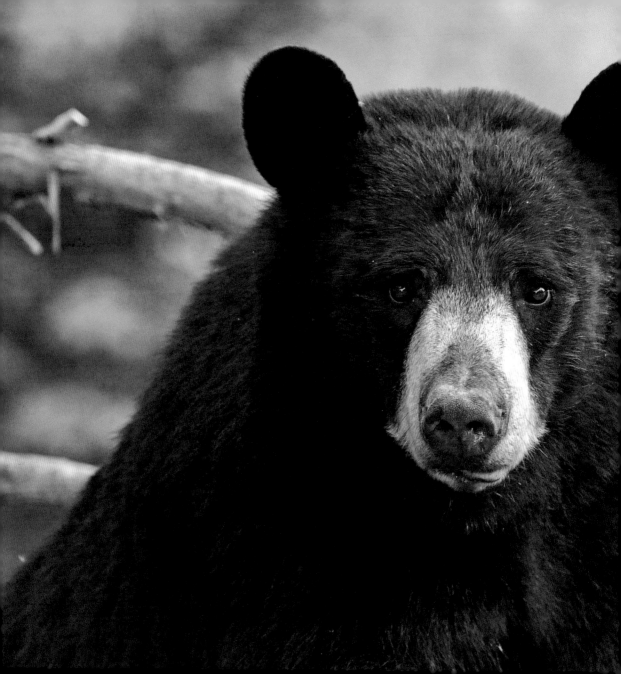

**Do I WHAT
in the woods?**

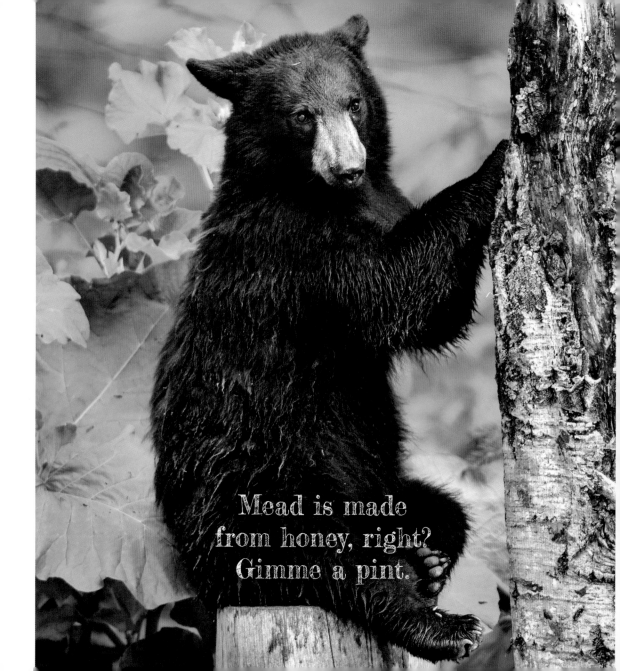

Mead is made
from honey, right?
Gimme a pint.

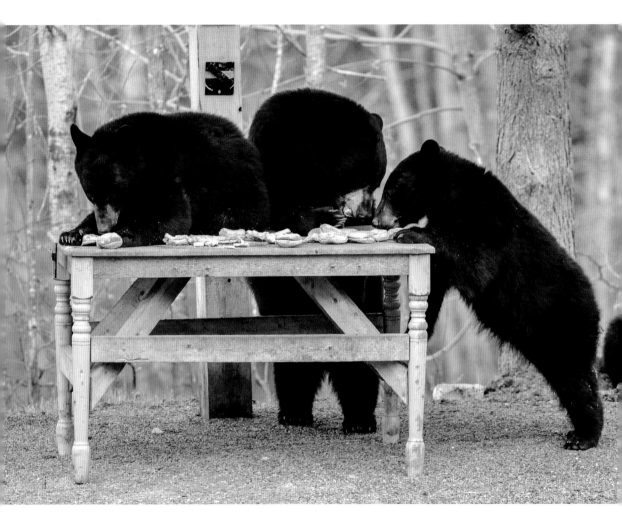

What you don't grab is what you don't have.

Don't touch anything
on the ground.
We don't know if the
humans washed their
hands before throwing
it there.

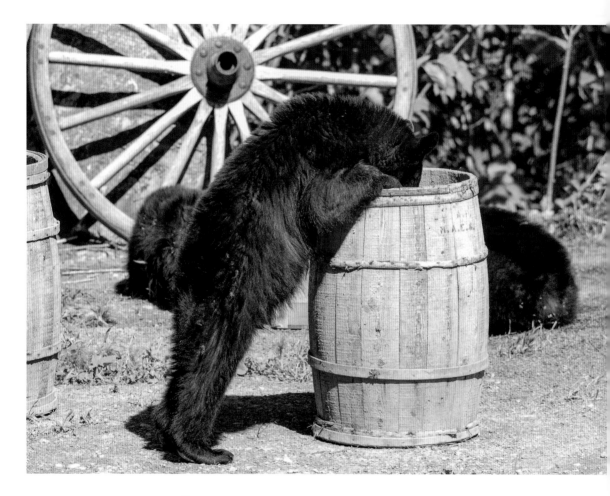

I threw in my coin, but
my wish didn't come true.

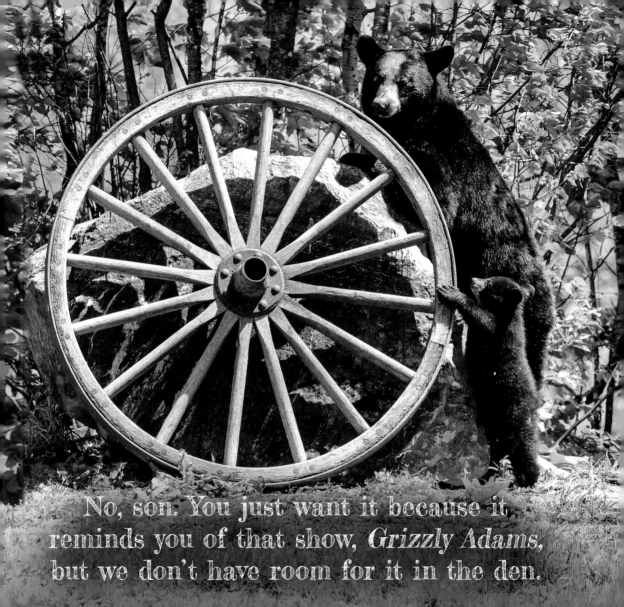

No, son. You just want it because it reminds you of that show, *Grizzly Adams*, but we don't have room for it in the den.

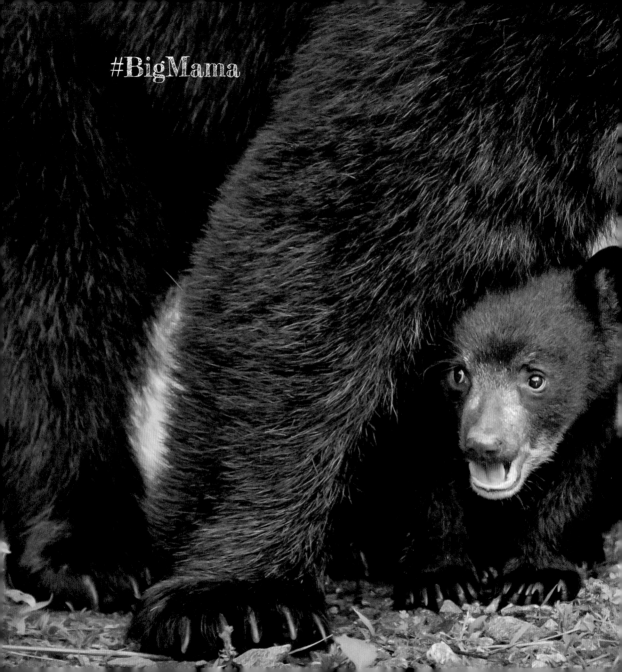

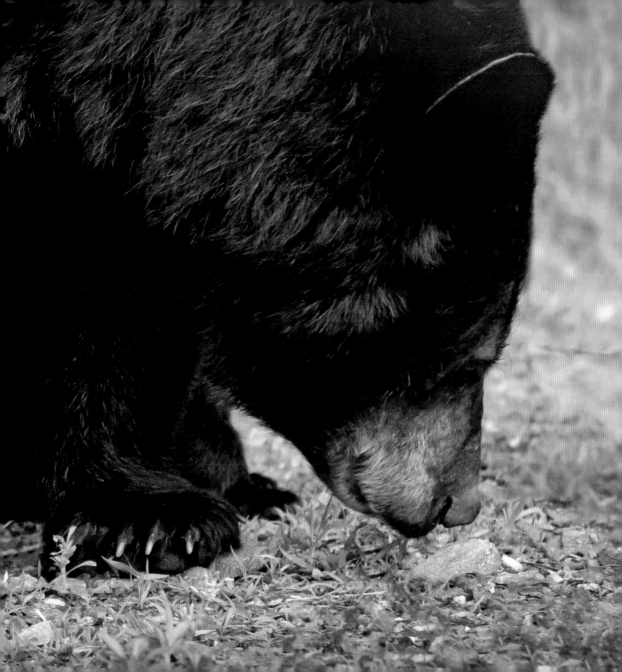

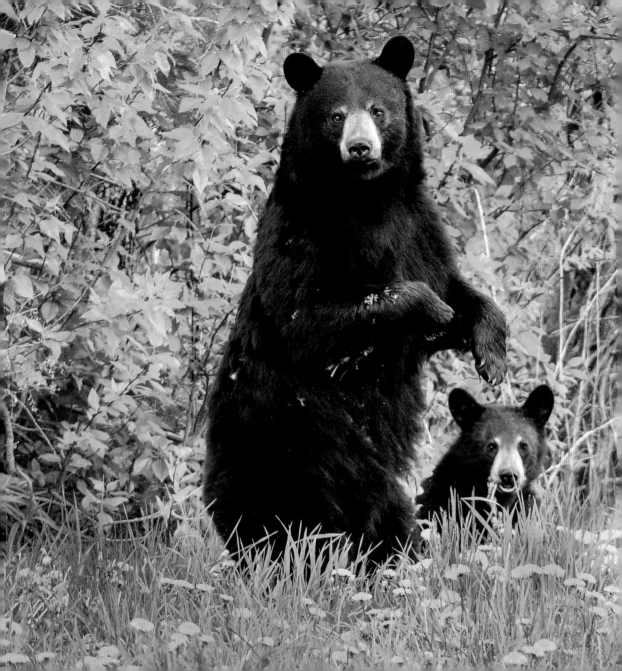

Smile, those pix are going to be our ticket to the big time.

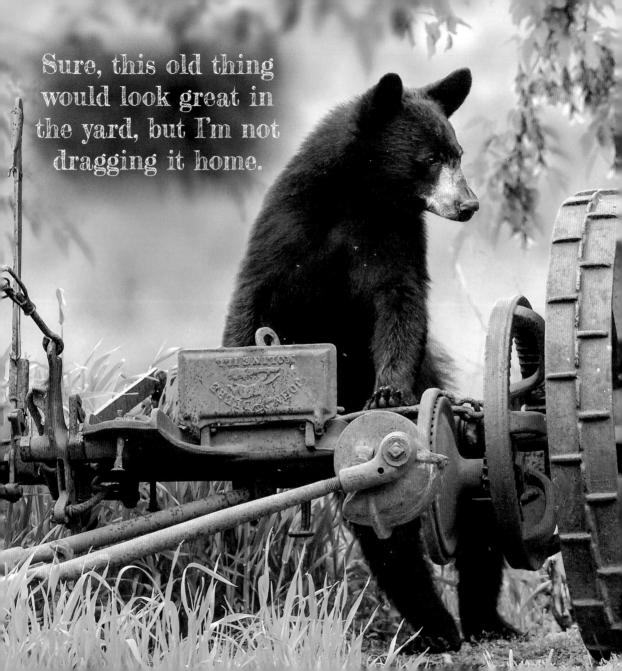

Sure, this old thing would look great in the yard, but I'm not dragging it home.

How am I going to explain where
all those potatoes went?

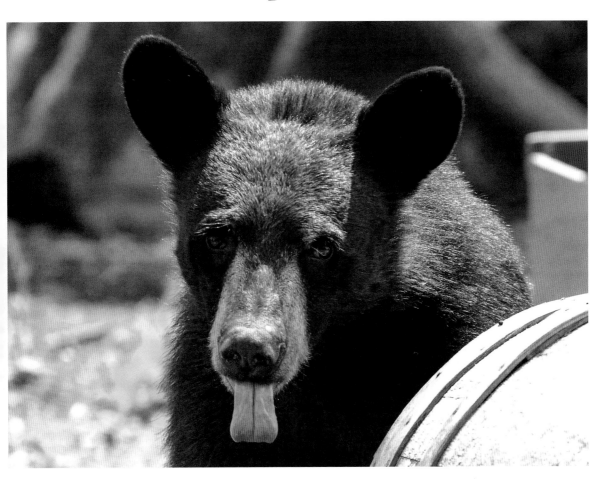

They say these things
are all about torque,
whatever that is.

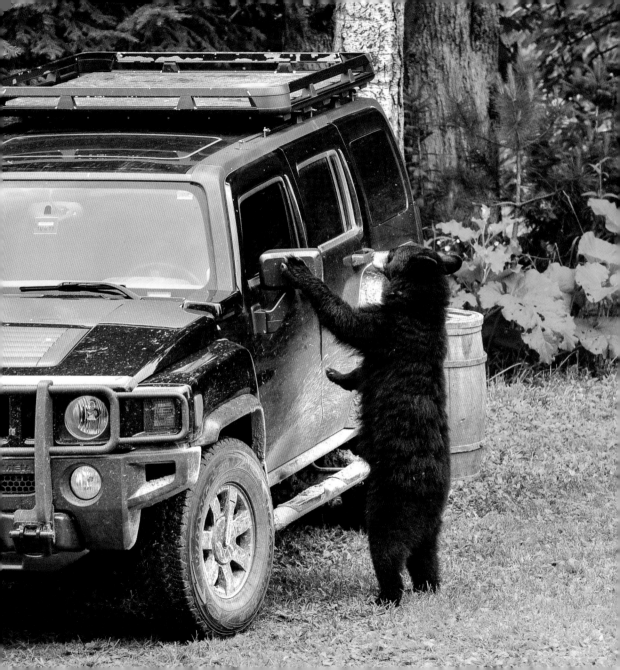

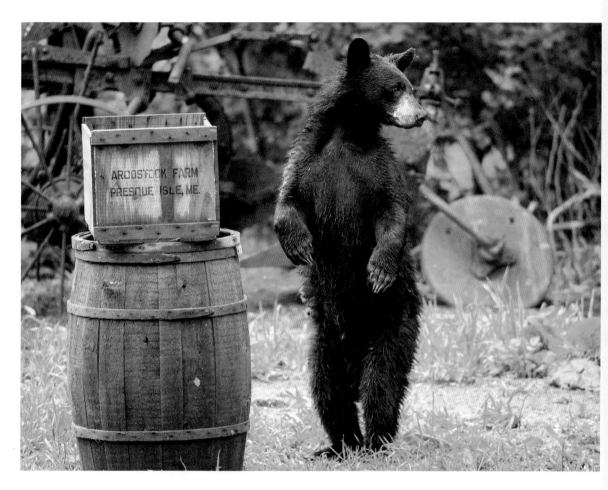

If I don't leave any footprints,
they'll never know it was me.

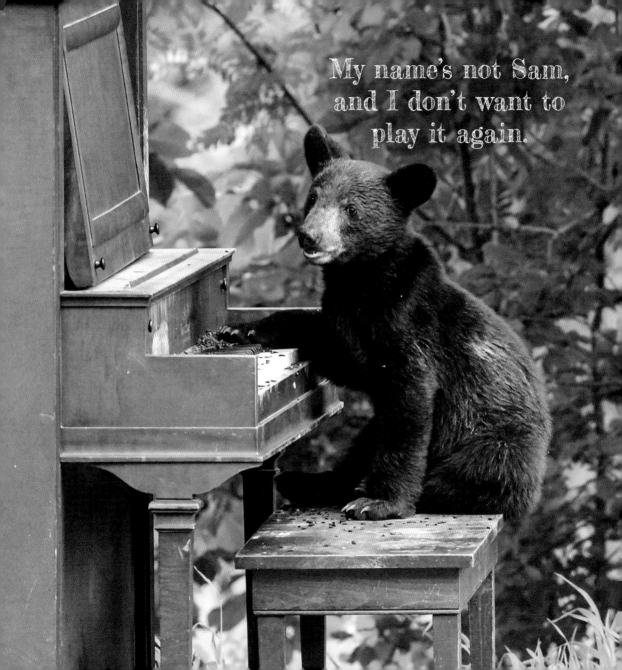

My name's not Sam,
and I don't want to
play it again.

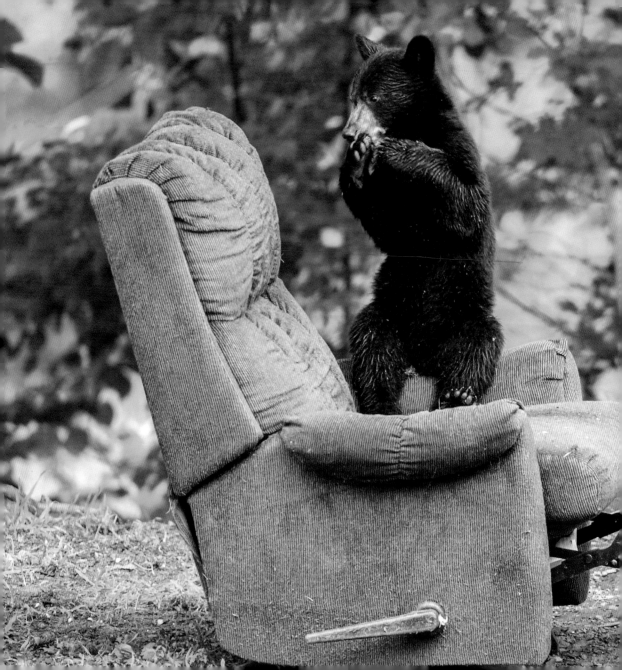

Uh oh, now
I've done it.

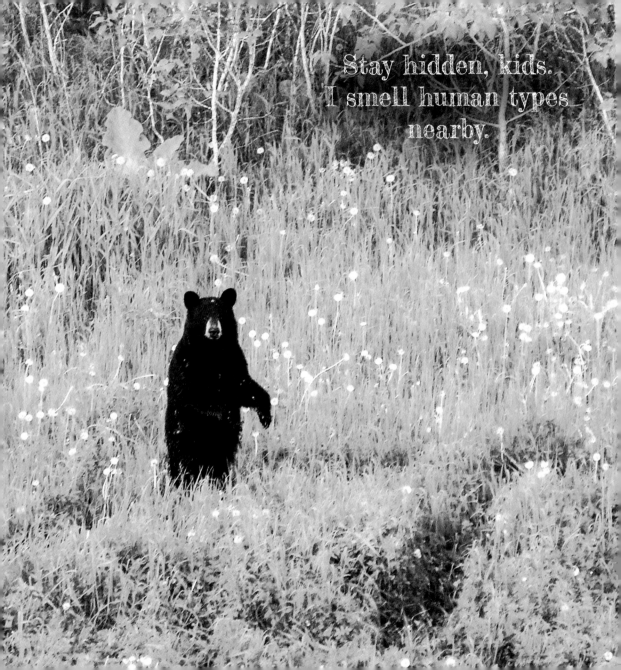

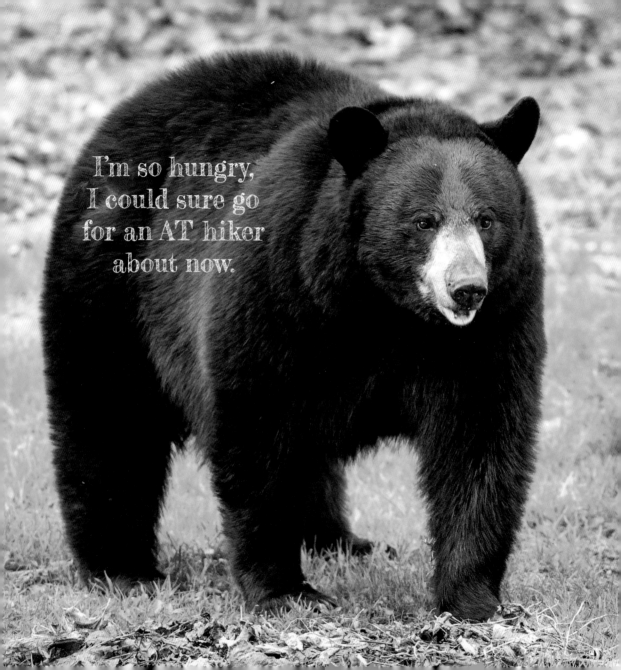

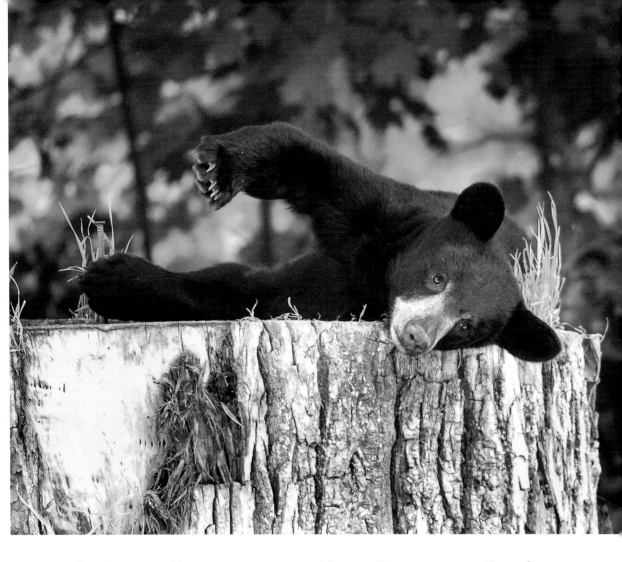

Can you have a negative sleep number?

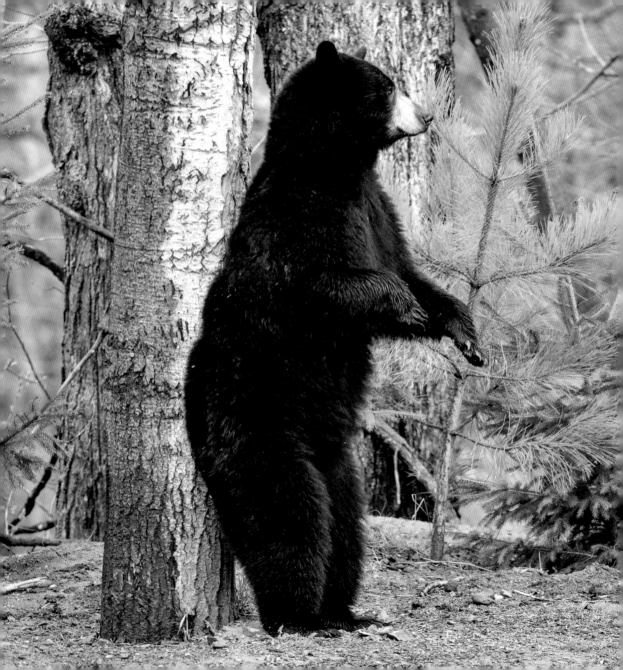

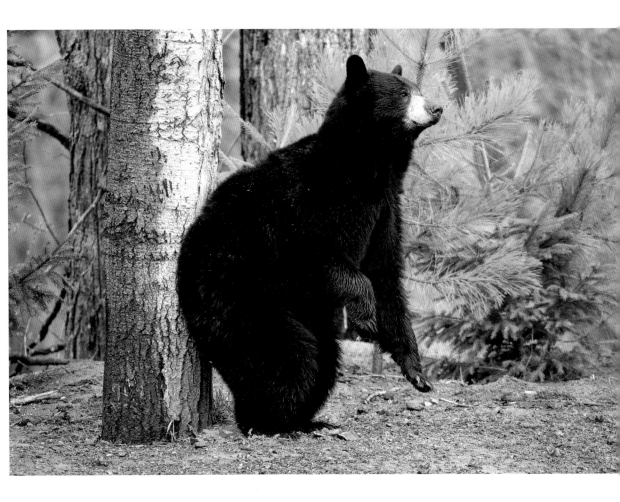

I never pass a tree without
giving my butt a good scratch.

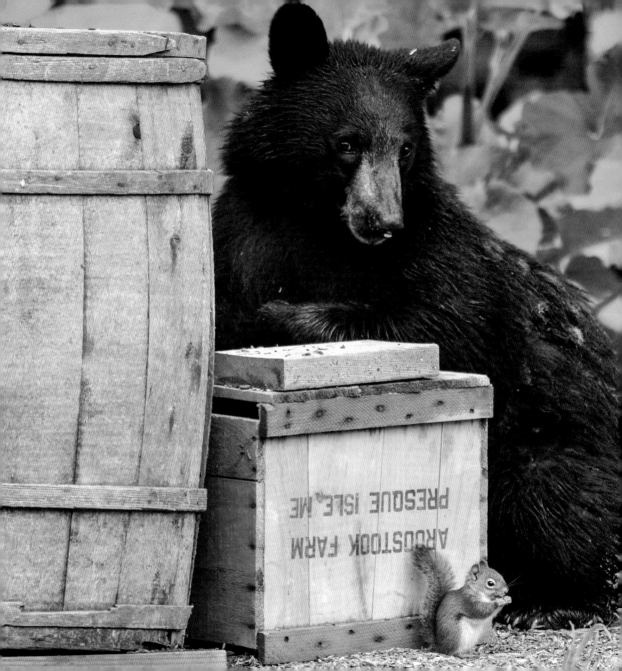

AROOSTOOK FARM
PRESQUE ISLE, ME

Those mashy apples
sure tasted good, but
now I'm feeling tipsy.

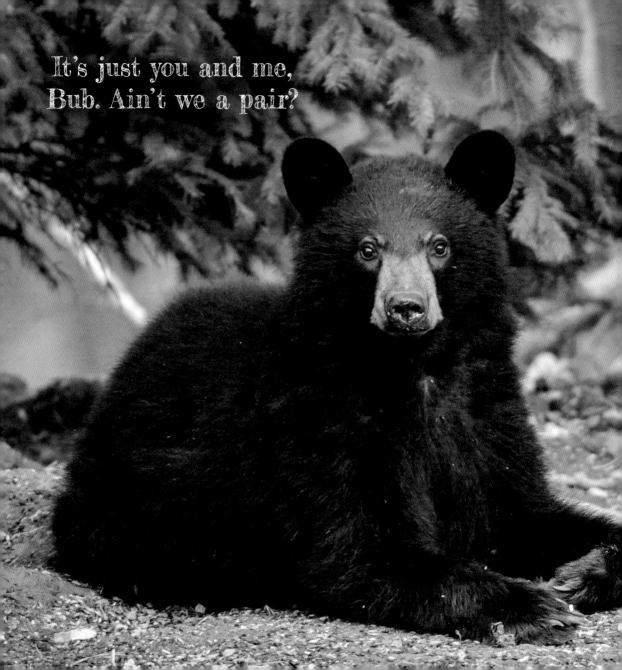

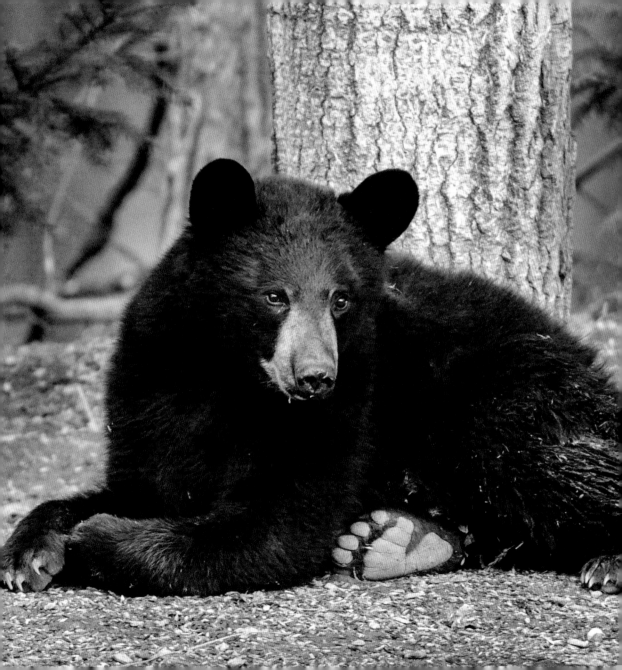

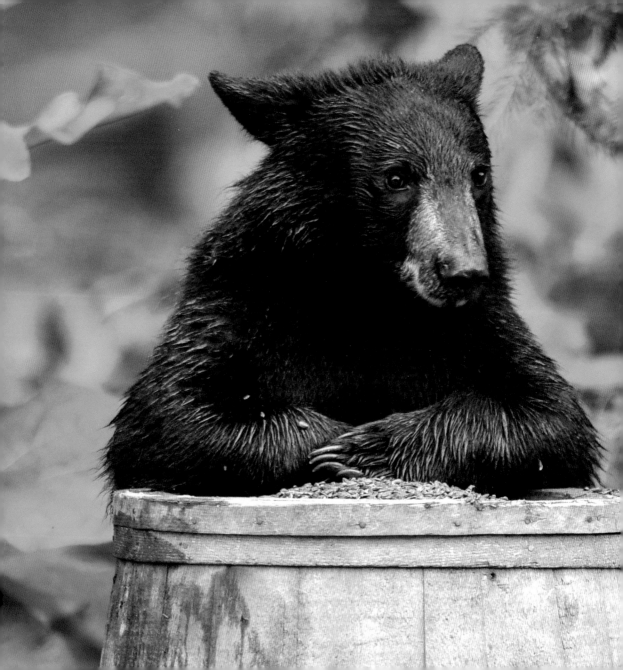

I wonder if this stash is considered medicinal or recreational?

Meh. Just not
feeling it today.

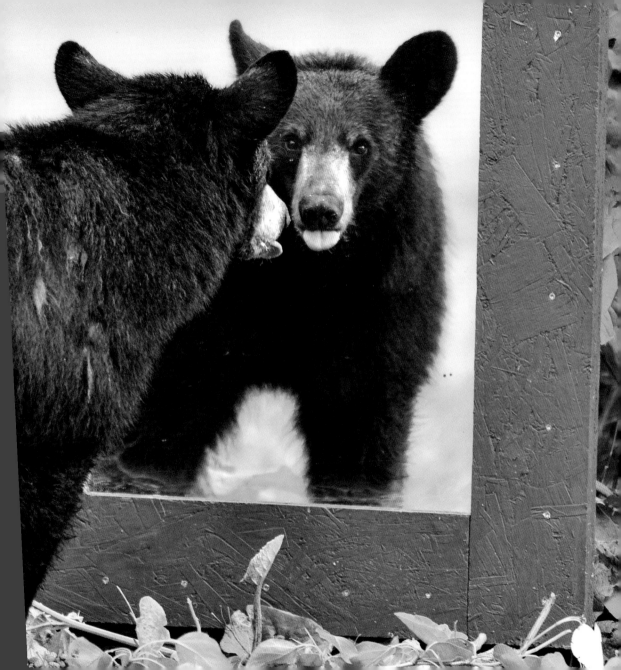

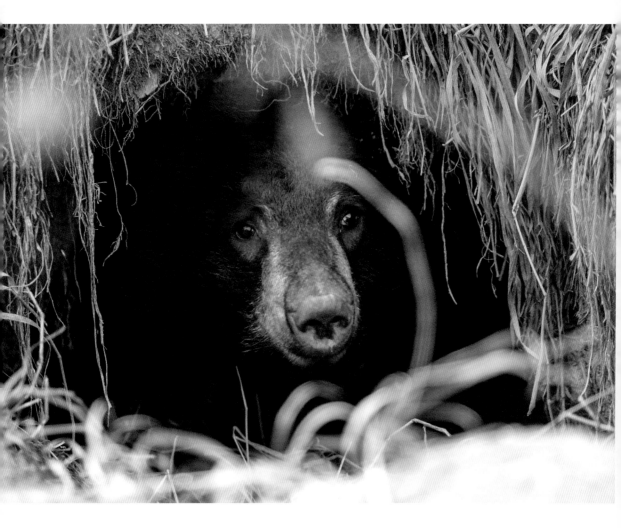

I'm not coming out until you apologize.

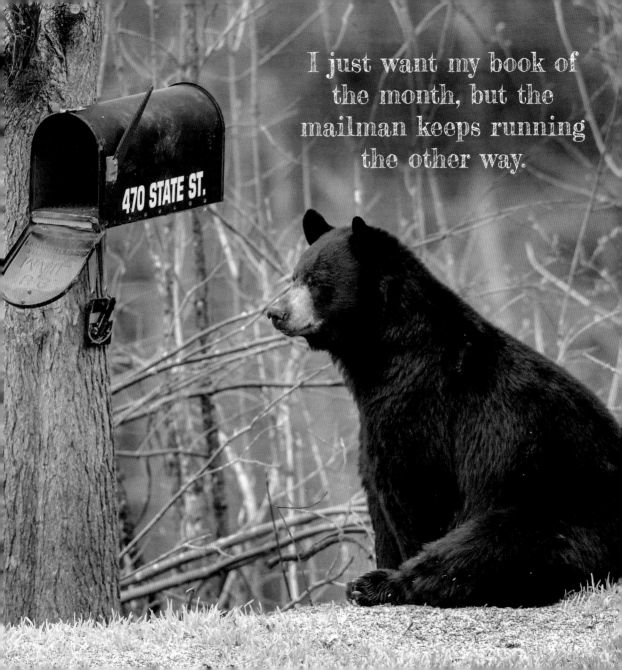

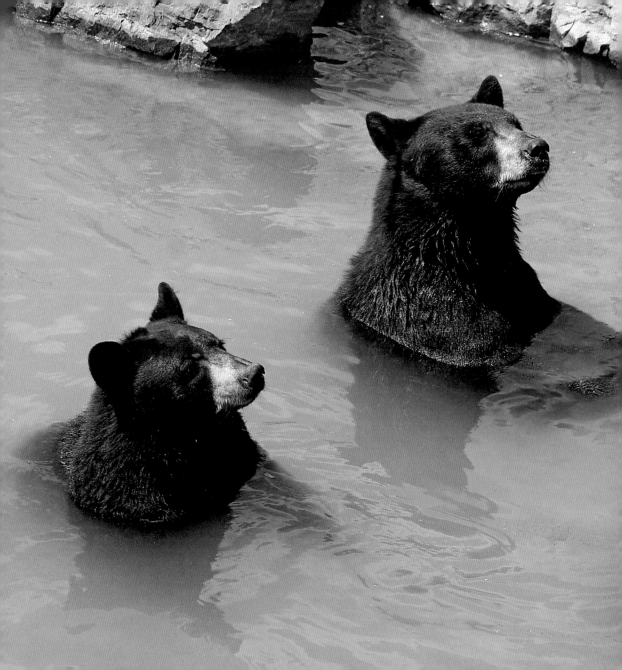

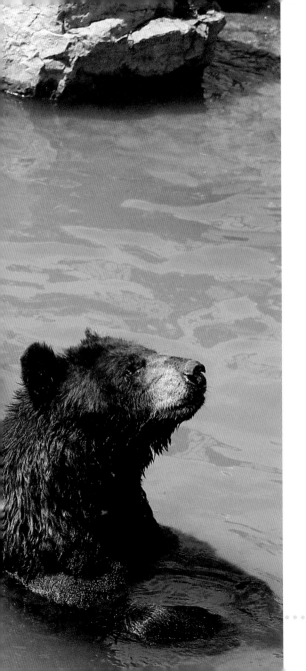

If you make it past all three of us, the waterhole is yours.

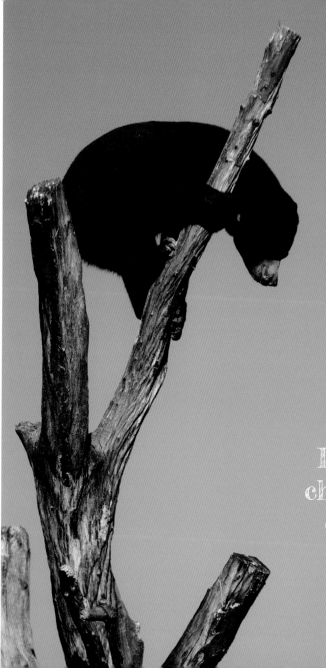

I'm gonna need a
cherry picker to get
down from here.

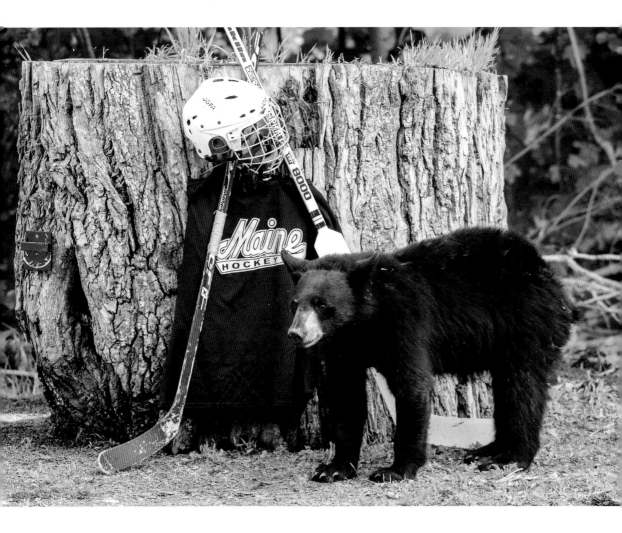

I only like hockey for the fights.

The damage Yogi Bear
has done to the bear
image may never
be repaired.

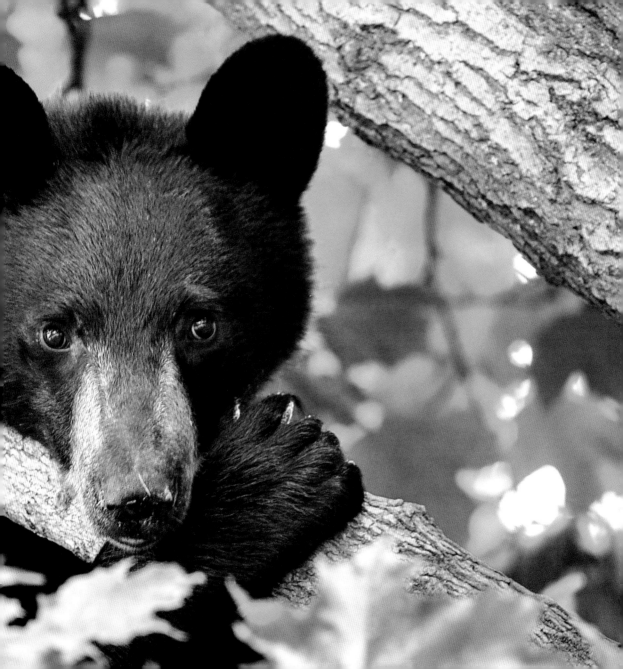

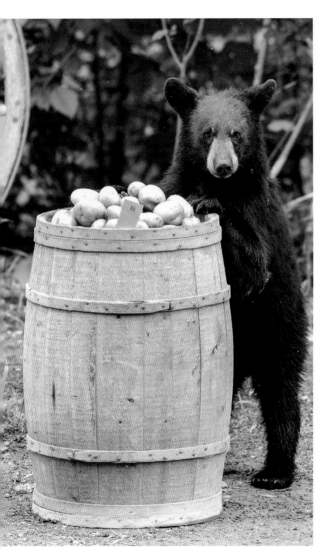

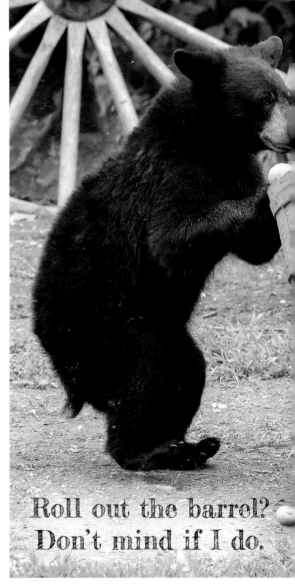

Roll out the barrel?
Don't mind if I do.

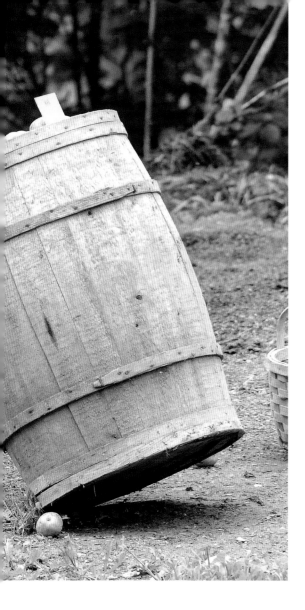
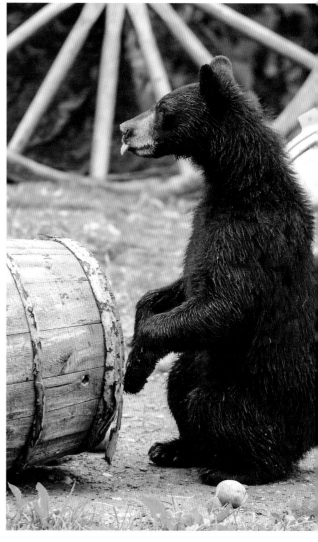

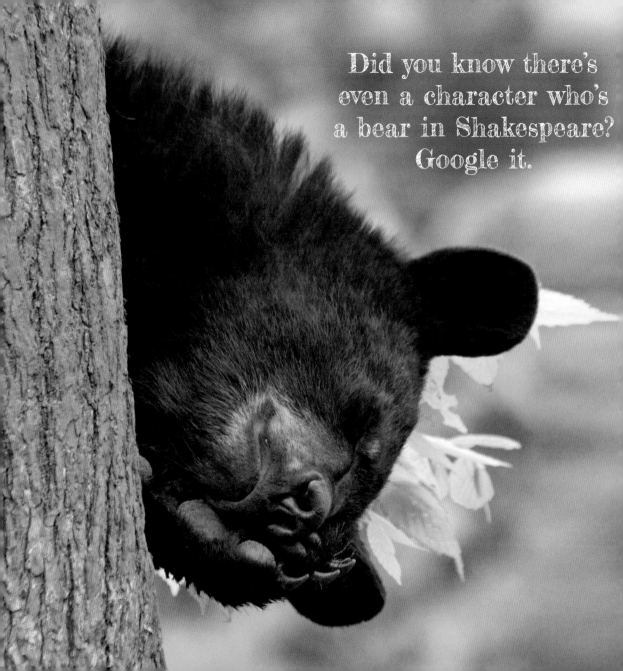

Did you know there's
even a character who's
a bear in Shakespeare?
Google it.

A big belch after a large meal,
and then I have room for dessert.

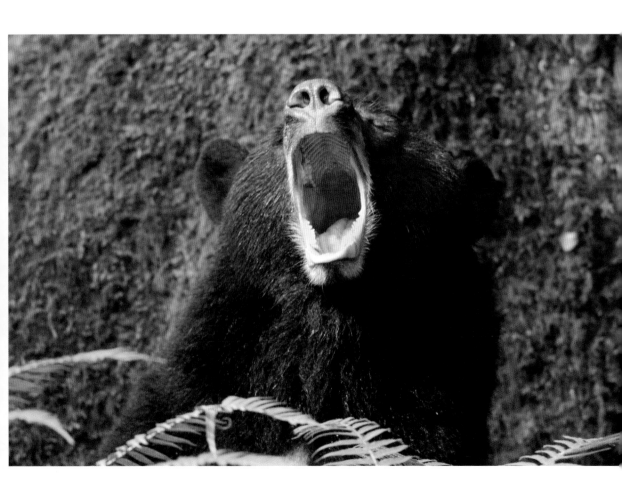

I'm not movin' until
nap time is over.

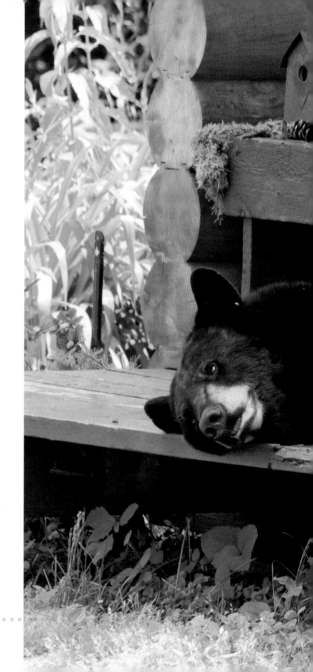

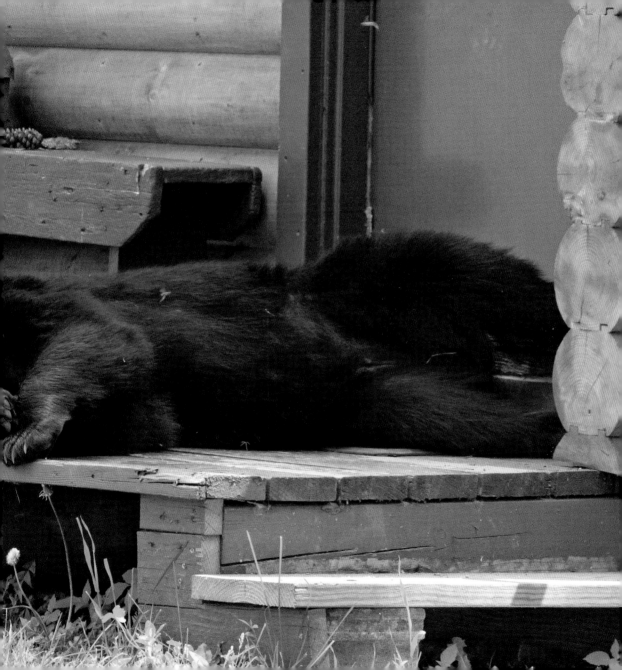

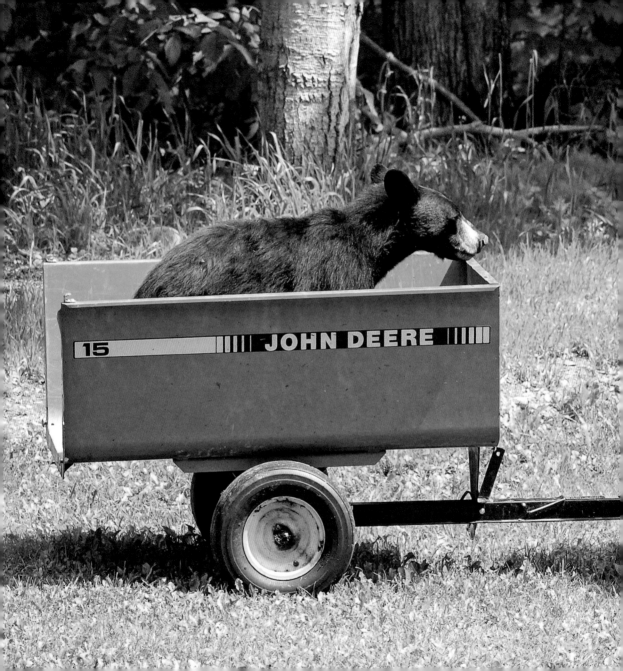

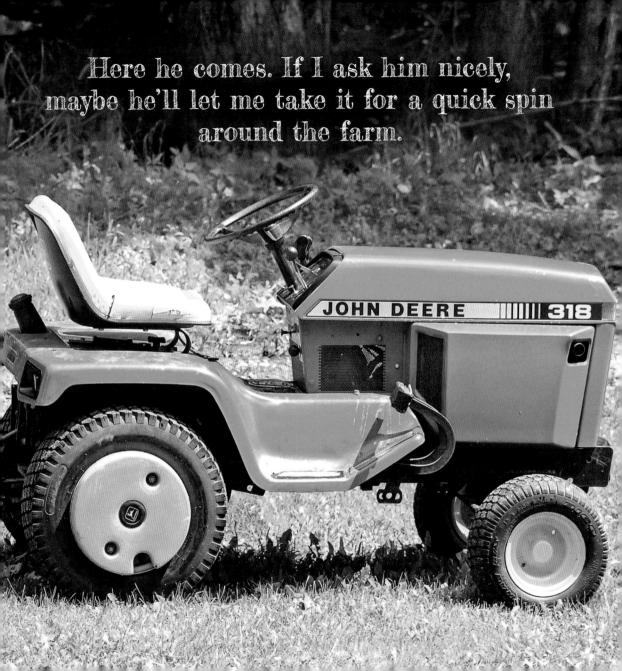

Here he comes. If I ask him nicely, maybe he'll let me take it for a quick spin around the farm.

I'll have the Honey
Nut Cheerios with lots
of extra honey on top.

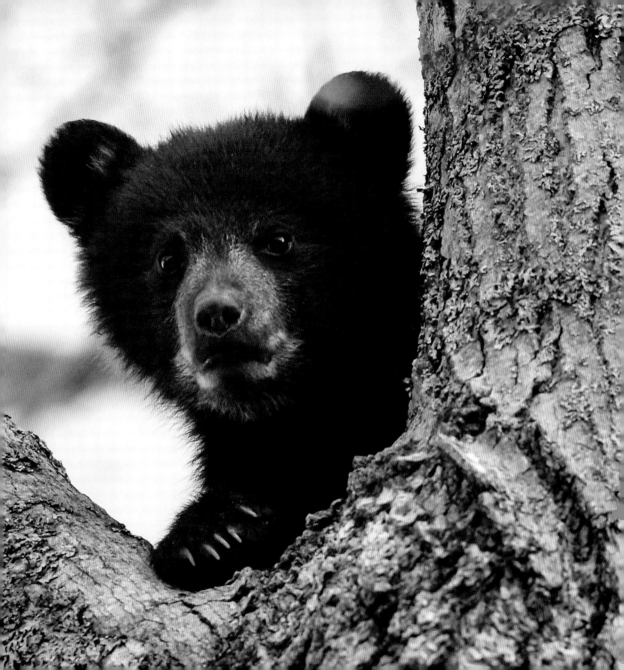

We bears have a good thing going here.
Don't think you and your rodent friends are
going to horn in on our action.

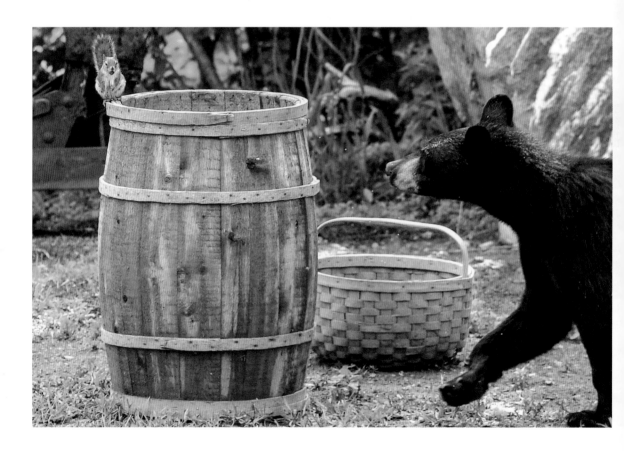

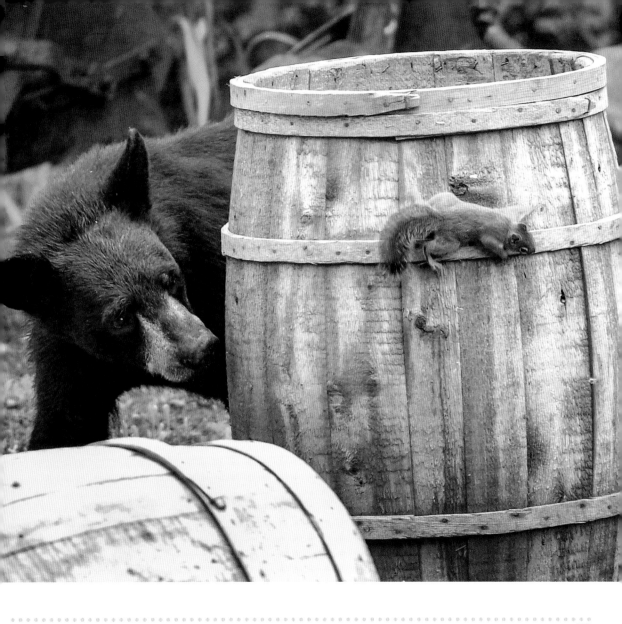

I'll tell you a joke,
but I won't light
your smoke or
Smokey Bear will be
on my ass.

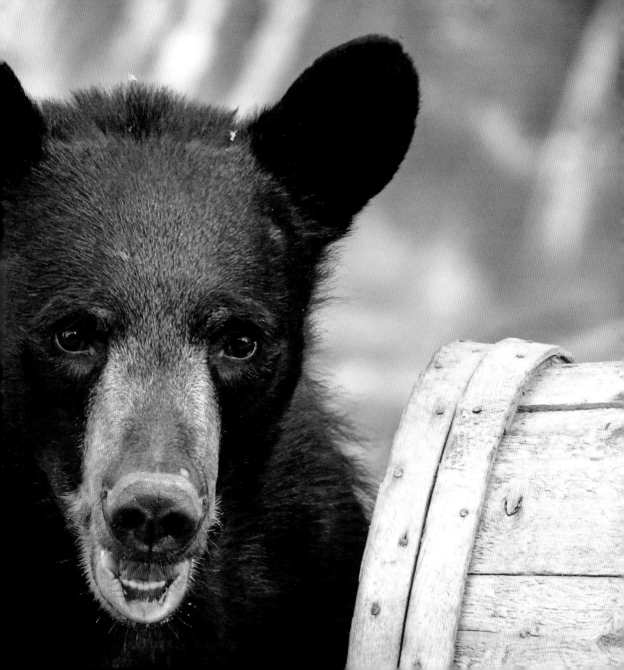

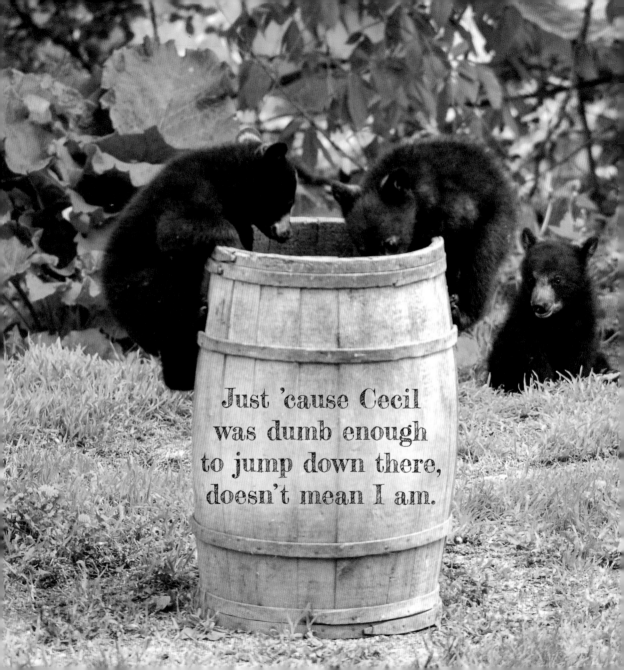

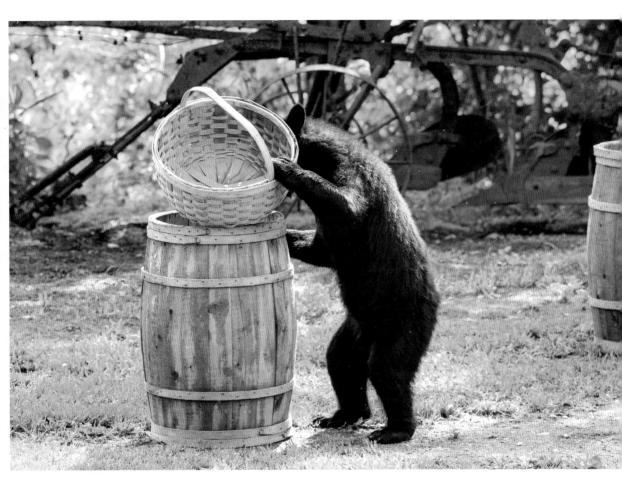

Ah ha! Thought they could hide the good potatoes from me, did they?

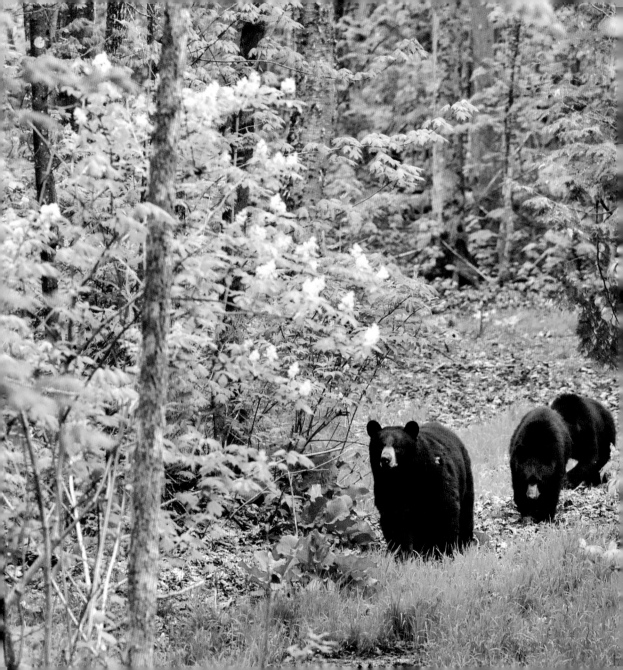

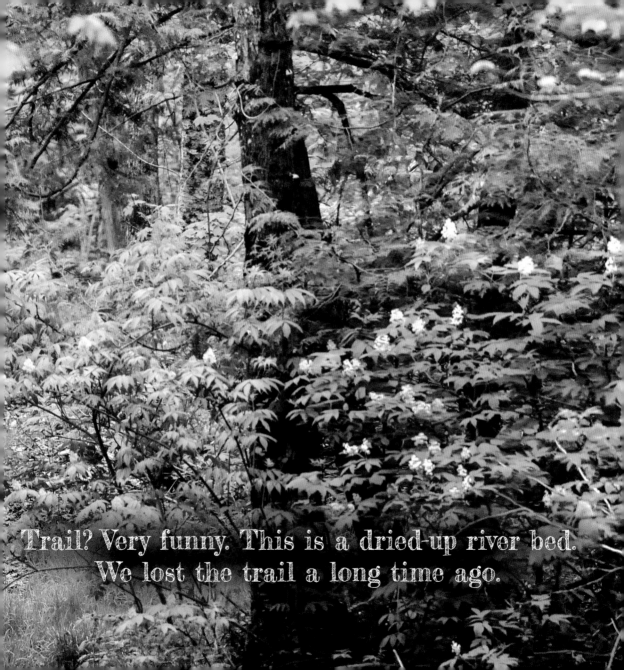

Trail? Very funny. This is a dried-up river bed. We lost the trail a long time ago.

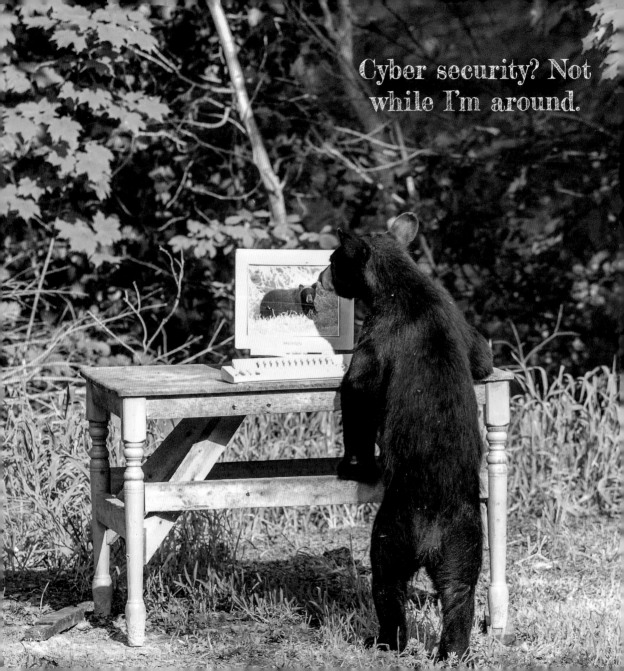

Cyber security? Not while I'm around.

Just sign and drive—this baby
has payments even I can afford.

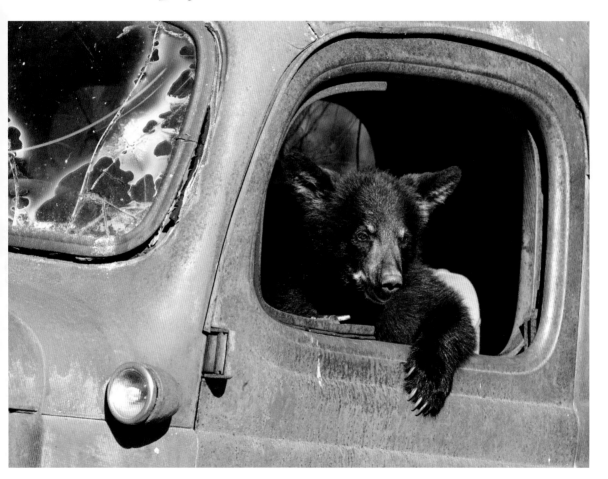

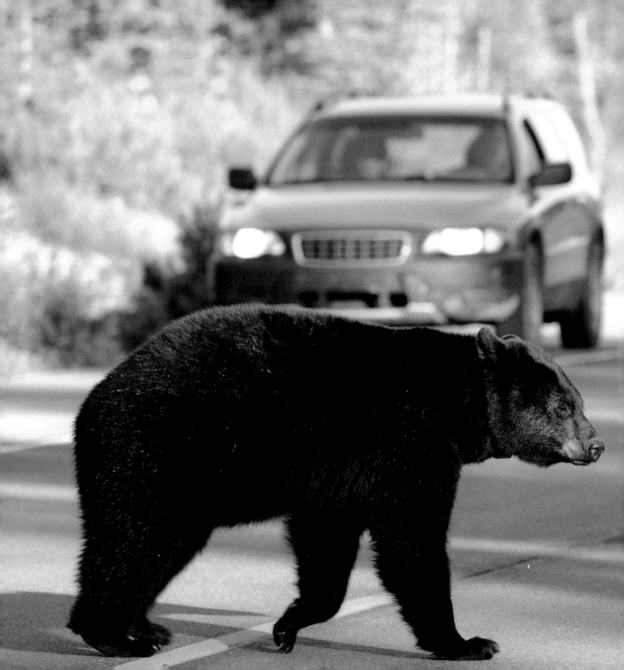

Life moves at
our speed here in
the woods.

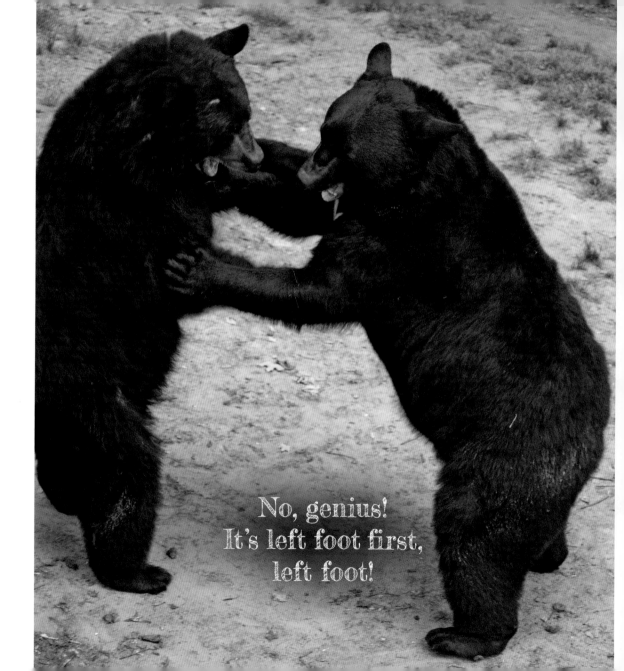

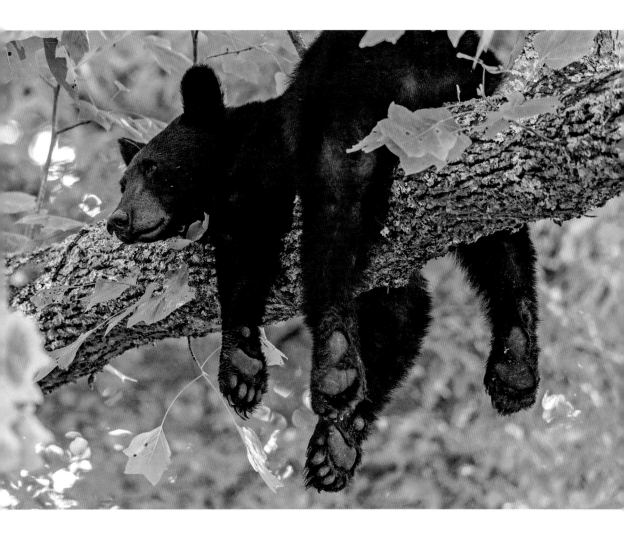

Mind if I hang around?

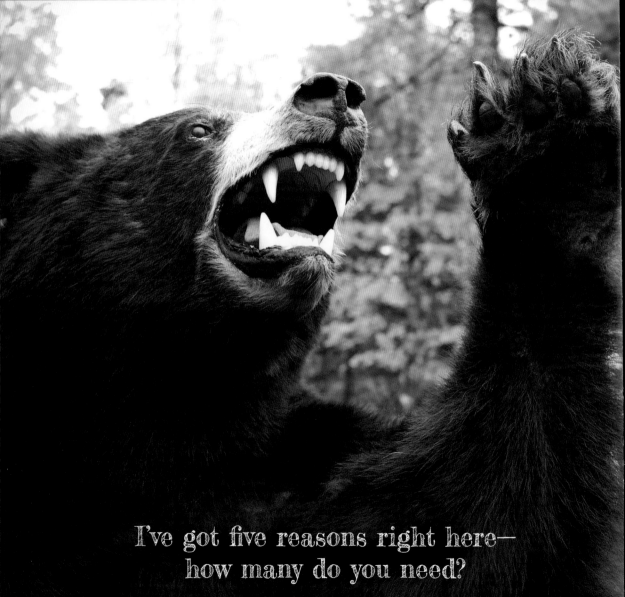

I've got five reasons right here—
how many do you need?

I wish people liked feeding bears
as much as they like feeding birds.

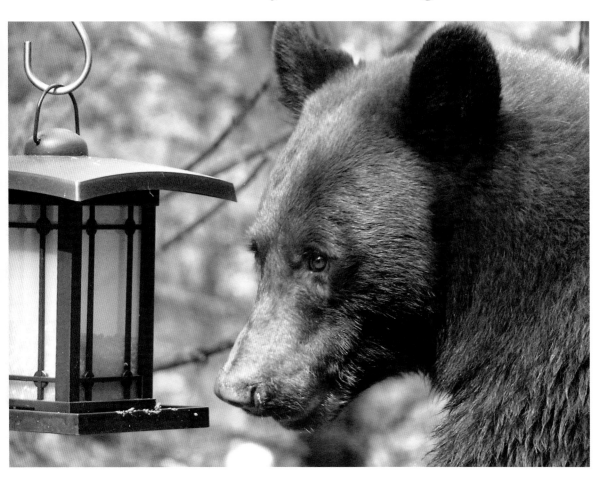

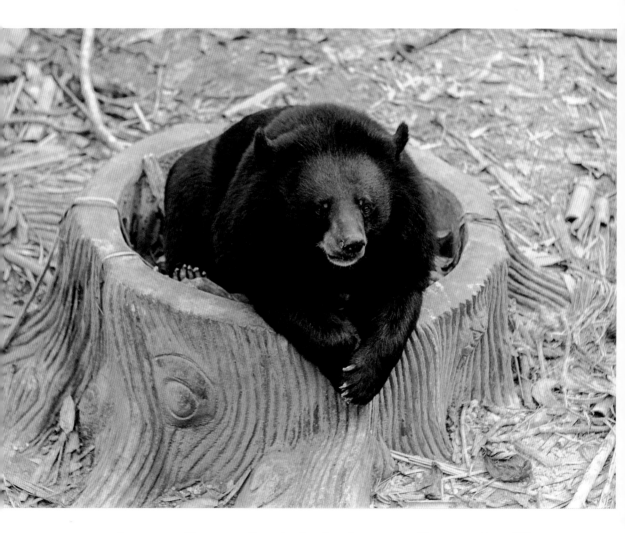

A one-bear hot tub is no fun at all.

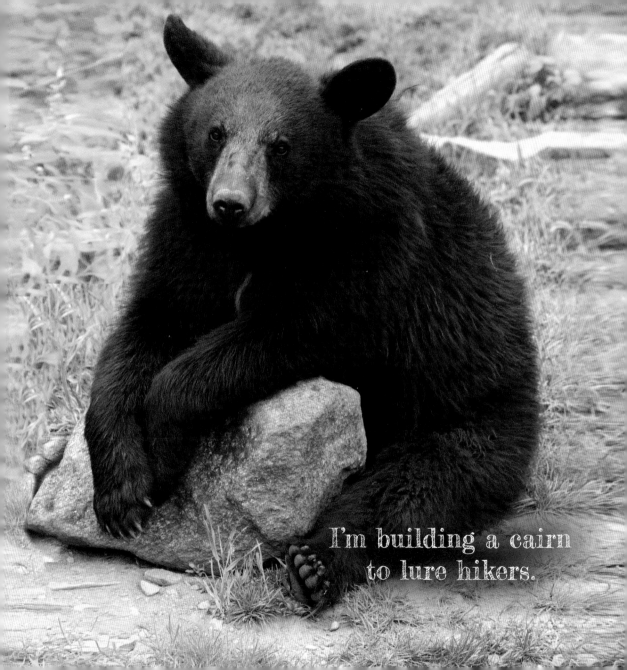

I'm building a cairn to lure hikers.

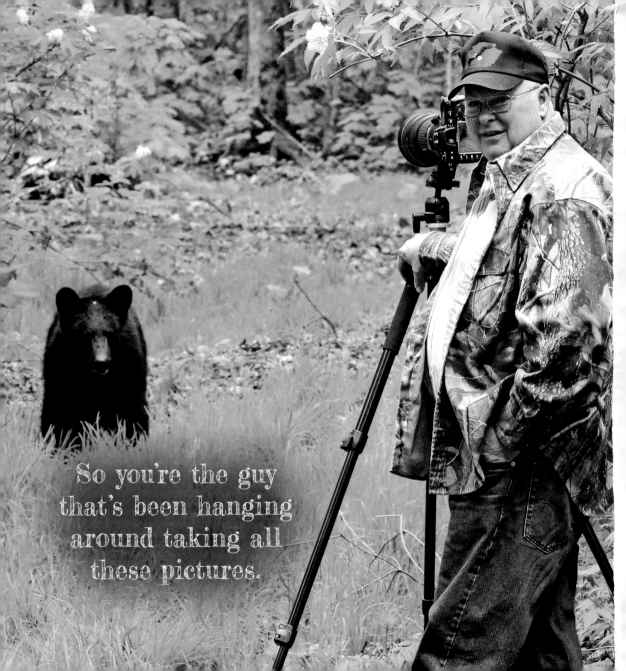

So you're the guy that's been hanging around taking all these pictures.